U0015480

密件副本

BLIND
CARBON
COPY

自問自答

身為一個固執且試圖挑戰、提問當代建築的台灣建築師，為何在漫長的人生歲月中有一段青春的「漫畫」旅程呢？

緣起，就讀淡江大學建築系時，由於本身喜歡繪畫，被張文瑞老師發掘、挑選為改編亞力山大「模式語彙」的總負責，並且望文生義的繪製所有插畫。當時，抱著初生之犢不畏虎的精神，天馬行空、自由自在的發想。書成之後，其中的插畫竟也意外獲得許多好評，及許多同儕的模仿學習，甚至獲得當時《建築師雜誌》主編王增榮老師的認可，邀請繪製了好幾期的「建築插畫」。

後來，出版《模式語彙再現》一書的尚林出版社王德進先生更推薦了當時任職民生報「思想奇人」李沛先生，在他的鼓勵之下嘗試漫畫的創作，也讓我在建築事務所學習過程的下班閒暇時刻，與李沛先生在人生、哲學、漫畫有一段忘年之交且與他常常有深入交流，溝通與學習的機會。

環顧當時台灣「漫畫」環境的現象，大家畫的都是插畫般的漫畫，如果把文字抽離，就變得非常乏味了。因此，我認為最厲害的漫畫，是文字說明越少越好，甚或不立文字，「點子」勝於「奇淫巧技」。

這本「漫畫」是我青春歲月成長的記事，期待有心之人，能看出書中「弦外之音」的奧妙，希望這本「漫畫」的出版能記念我的父執輩好友李沛先生的一段友誼，也特別謝謝台灣紳士——台灣共和國出版社老闆郭重興兄的賞識與出版，更謝謝編輯廖祿存兄的用心。

廖偉立

MONOLOGUES

Being an insisted Taiwanese architect who challenging and questioning contemporary architecture, why does he has a youthful period of "comic" during his long journey of life?

Dependent arising from the education of Department of Architecture in Tamkang University, my passion of painting had been discovered by professor Wei-Rui Zhang , and he chosen me as the general responsible for adapting " A Pattern Language: Towns, Buildings, Construction "written by Christopher Wolfgang Alexander, and drawing all illustrations by understanding the meanings of the book. At that time, holding the spirit of "Fools rush in where angels fear to tread.", thinking freely without limitations.

After the book was published, the illustrations unexpectedly received many praises and imitated by peers, and even invited by Mr. Zeng-Rong Wang , the chief editor of Architectural Magazine, to draw several issues of architectural illustrations at that time.

Later, owner Mr. De-Jin Wang from Sunny Books Publishing House, who published "Reproduction of a pattern language", recommended me to Mr. Pei Li, the "Thinking Man" of Min Sheng Newspaper. With his encouragement, I tried to create comics in my free time when I back from architecture firm. It allowed me to have opportunities in communicating, learning and exchanging of viewpoints in philosophy, life and comics in-depth with him.

Looking around the phenomenon of Taiwan's "Comic" environment at that time, everyone drew comics like illustrations. If we take away the text, it becomes very boring. Therefore, I think the most powerful comics are the less textual description, the better. Even without words, "ideas" are bigger than "splendid skills."

This "Comic" is a memorial of my youth and growth. Expecting those who are interested in discover concealed idea behind in the book.

I hope this publication of comic will commemorate the friendship with Mr. Pei Li , a friend of my father's generation , and also the special thanks to Taiwanese Gentleman - Mr. Chong-Xing Guo, the owner of Book Republic publishing group, for his appreciation and publication, and for the dedication of the editor Lu-Chun Liao.

幽默漫畫的解讀

「純幽默」的漫畫，不論在國內外都一樣，很多人都說看不懂，照說漫畫的取材和訴求，都脫離不了現實社會和日常生活，它並不像抽象畫和新潮詩那樣只訴諸於「主觀」和「感覺」，無關「客觀」與「理性」，幽默漫畫之所以看不懂，應由於它的思考模式和常識的思考模式有所差別，因之在接受心態上造成像岔線和斷路的「不來電」了了，易言之也就是要用「漫畫的邏輯」來解讀漫畫，可是什麼才是漫畫的邏輯呢？

通常我們認為，不論國畫或文字，都必需有理性的邏輯，合乎常識具有意義。如果從合理化和意義的角度來解讀幽默漫畫，就無異「兔毛求角」了，所得的結論準是：「不可理喻！可不是荒謬錯亂？」殊不知幽默漫畫所要表達和詮釋的正就是「反常」、「意外」、匪夷所思的「非合理性」。

我們生活在現代社會裡，日常所接觸到的可以說盡是繁複冷酷的理性規範，機械程式，數據符碼，甚至相互溝通的語言和表態，都變成僵硬的模式化了，人卡在這種理性禁錮的社會機制裡，變得焦慮、壓抑、緊張、笑容消失退化了，或變得虛假、僵硬，「自我」喪失……在這一連串工業社會的「疏離」癥候群中，人還是要活下去！為了抗拒和對治這種理性主義強勢統治加給的禁錮與壓力，「非理性」就成為現代人渴望中的逃藪和「最愛」了，「非理性」滲入文化理念和社會行為成為一種傾向，從日常生活中涓滴的淤積聚合，匯成狂飆的潮流，從思潮、文化特徵到流行風尚，無所不在的感染到了，泛濫著理性主義和非理性傾向的衝突和決擇。今天又臨世紀終末的交接期，「非理性」的戰爭和擴散還在持續漫延……。

漫畫誕生才二百年，它的成長，漸成氣候只在本世紀，剛接落在這場思潮之戰的場景裡，截當的說幽默漫畫，不也就是這種思潮情結中的產物。幽默漫畫就在非理性的基調上，用反思來抽繹出各種理性的詭詐和變形，常識的慌失和意外。觀賞一幅精采的幽默漫畫，除了得到由「非理性」轉折到新的理性啟蒙和契機，在感性的圖象中，使人如同味檳，澀後還甘，也像驚豔，驀地來電，「幽默」帶給你出乎預期的意外，瞬間的驚喜，使壓力和禁錮像蛻脫冰繭紓解回甦，原始性的機制和活力，得以活絡出枰了。

非理性之與荒謬錯亂，可以畫上等號嗎？倒也未必，雖然看來相像，那只是它的表象和權詮而已，漫畫故意扮個鬼臉，其實是要與「習慣」挑戰，向常識嘲諷，對理性質疑，耍耍虛招而已，究竟，還有它要正經說明的「什麼與什麼……」。

意識和世事往往是循著辯證的路標行進的，世界上那有永久不變的真理！今天炎炎固執的「善」，異時可轉變成甩之不掉的「惡」，有所謂「積非成是」，就可能「積是成非」，正如同正正得負，負負得正，後面還有枝「時間」的魔棒在運作，幽默漫畫就是在正、負和時間的辯證對話中搬演的默劇。

每一幅漫畫，除了它詭異的構圖外，都隱藏着一個「點子」，所謂「點子」，就是圖畫套上一個相關又巧合的事例，也即借喻，「點子」在漫畫的幽默基調上耍出各種吊詭的變奏，構成漫畫的多樣姿采。

漫畫愛唱反調，似乎也是所來有自，找出它的淵源；它就遺傳着中國文明裡的「犬儒」脾氣，蘇東坡的滿肚子不合時宜，到徐文長、金聖歎、鄭板橋，幾乎也是漫畫氣質的傳統脈承，漫畫扮演烏鴉嘴的角色，只啼報危機意識，最愛向規範、教條、「標準答案」發難找碴。如果對它能深一層來體認，漫畫否定現實裡的「肯定」，目的是要說否定這一段上找尋新的肯定。在漫畫的邏輯裡是，熱釜裡也會爆出冷票，現象是中立的，掌握機宜，端在監視着潛在面的「黑箱作業」——「變數」。

只有透過辯證思考完成的作品，才夠得上稱「創作」，幽默漫畫都是獨立思考的個人觀點，故每幅漫畫都是創作，它不出自學院，也沒有師承，更無論派系了。在繪畫裡只有漫畫「小道」，不師聖賢只法造化，它是斷代的，只有橫的走向；它是孤峭的，像獨行俠，野狐禪，羅漢果；它的作業，不妨危言聳聽，卻是直言談相（指訴求的內涵）。

漫畫的構圖技巧，看來似粗疏醜怪，像童畫、塗鴉，其藝術性卻有嚴緊的判準，譬如說：同樣揮筆畫條弧線，常人之與「大匠」手迹，若在高倍顯微儀器的檢視下，線條都化成了粒粒點點，其組列的程式迥異，精奧粗亂之迹立見，顯示出繪事中功力之務決非唐捐，造詣境地更待百竿歷練，信然不誣。漫畫技法援用簡筆、漸法，迥不作等衡之評估也。

接著幽默漫畫順可談談「幽默感」，「幽默」兩字，大家經常瑯瑯上口，但幽默的內涵義蘊，卻是精奧微妙，機杼多道，不是人人所能了解的。尤其是在實用上的「幽默感」，如何詮釋這種抽象的氣質？權且用反襯法來說明！與幽默感相對的是「尊嚴感」，常聽人說：「中國人是非常缺乏幽默感的！」這也就是說中國人是特別強調尊嚴感的！「尊嚴」是別人對您的景仰、觀感，但是「尊嚴感」呢？卻是

不客氣的「夫子自道」，自我誆封介樣了，由這種情操的衍伸，則一概，刻意的包裝，斤斤於面子，各式偽善的虛矯作態，都在管屬，成其「連線作業」。說實在，這一脈扮相，果然唬人，可也惹人厭惡透頂！如果掀翻它的底牌；這種表態，可不正是為了平衡其內在的空疏不學，或「過氣」自憐的心態，十足是自卑感的反射而已。

廖偉立的漫畫就屬於這個分類；「高檔的純幽默」，他的漫畫驟看之下，使人覺荒謬神經！但是你若本諸漫畫的邏輯，心態一忖，却會不禁莞爾一燦，領略到「深得吾心」之樂，它的「反理性」具有正面價值和說服性。但估量現在的市場趨向，它沒有像連續劇，麻將，電玩誘人，魅力的「賣點」，因之我保證它上不了暢銷排行榜，或許也是對現實社會的一個考驗，如果事實發展出於我的意外，倒反成為出版界本年第一號上榜的幽默新聞了。

李沛

Interpretation of humorous comic

"Pure humor" comic has always been very popular at home and abroad. However many people say they fail to understand what the author is driving at. In general, reality and daily life are used as motif of comic most often. Unlike abstract painting and new trend poetry which resort to "subjectiveness" and which have nothing to do with " objectiveness " and "rationalism". The reason why comic can't be understood is due to the difference between the common sense and comic thinking mode, and this probably is the reason for some people's failure to read between the lines. It therefore constitutes a fork line in readers' attitude, just like a short circuit's inability to communicate between two persons at both ends of phone line. Therefore it is essential to use "comic logical thinking" in reading comic. But what it is ?

People always conside "Painting or writing should be reasonable and logical." If we interpret comic from this point of view, we will conclude that comic is nonsense and absurd, not knowing that "abnormalism" and "unexpectedness" are exactly what comic whishes to express.

In this modern society, complicated and cold rational discipline, mechanical formula, numbers, and symbols have always been what we encounter in our daily life. Even the language and the expression we use to communicate have become a rigid, stiff mode. Being stuck in this rationally bound social mechanism, we become anxious, suppressed and nervous, and our smile fades and turns into pretended and unnatural. Finally, we lose "sense of self" and become alienated in the crowd of this industrial society. We should be up to fight against the bounds and stress imposed on us, thus "irrationalism" has become the favorite asylum in this modern world. "Irrationalism" is seeping into our culture and social behavior. In every bit of our daily life, it has gradually accumulated and formed an overwhelming trend. It has contaminated everything from our thoughts, cultural features and vogue. The conflict between rationalism and irrationalism is everywhere. In the turn of the century, the war of irrationalism against rationalism is seemingly expanding endlessly.

It is only 200 years since the birth of comic which grows and becomes influential in the end of this century, the time happens to fall on this war of thoughts. We may say that comic is the product of this trends of thought. Comic are based on the irrational tone, using introspection to extract and interpret various rational and common sense deformations.

In reading a good comic, we are rationally inspired through irrational dissection. Just like chewing an olive, we taste puckery first and sweet later, and finally we see the light. The unexpectedness comic brings us to release from stress like a pupa breaks its cocoon and turning into a beautiful butterfly flying freely.

Can we put an equal sign between irrationalism and absurdness and nonsense? It may not be proper to do so. Although, they bear strong resemblance to each other, it is only a matter of the way of presentation and interpretation. Comic makes a face purposely in order to challenge our customs, to sneer at common sense and to question rationalism. If fact, it has something serious and meaningful to say to readers.

Consciousness and the affairs of the world are marching following the road sign of dialectics. There is no permanent truth in this world. "The good" we firmly believe today might become "the evil" we are eager to discard tomorrow. The false we are long used to may turn into the truth. It is the same case that negative multiplying negative makes positive. Behind changefulness, there is a wielded magic wand of "time". Comic is a silent opera that is playing among the positive, negative and time.

Except its tricky picture structure, there is always a concealed "idea" behind. That is to say every picture is put on a relevant, coincident event to give readers a hint.

The idea behind comic produces sorts of crafty tempo that constitutes the versatility and colorfulness of comic. Comic's inclination to sound a jarring note may originate from its inheritance from the cynicism of medieval culture. From Tung-Po Su, Wen-Chang Hsu Sheng-Tan Chin to Pan-Chiao Cheng, those famous Chinese scholars almost all inherited the traditional cynical quality of this kind. Comic is playing a picky role who is always reminding readers of consciousness of crisis, and who is most interested in challenging the accepted doctrines and standard answers. If we can further realize the inner side of comic, we will understand that the purpose of comic is to seek a new "positive" by means of throwing over the positive already accepted. Under comic logic, there is great possibility that ice cubes may be found in a hot pot above rageous fire. Phenomena are neutral. Only by monitoring the operation under the table---"variables", we can grasp every opportunity falling before us.

Only the works completed through dialectic thinking can be called "original works". All the comic are the products of individual's independent thinking from their respective viewpoint; therefore every comic is a yet its artistic qualities is unquestioned. A few lines drawn by average people and comic masters are quite different. If we inspect them under the magnifying instrument, we will find lines convert into little spots and their formula of array are distinctive. The feast of drawing cannot be obtained in a short period of time. The skills of freehand drawing, transformation and semi-abstraction are used in comic, turning complication into brief and depth into shallow to expressly present an idea. A few freehanded stroke of comic is in fact more sophisticated than fine drawing. Short writing or a poem of a few words can say much more. Thus it can make a deep and long impression on readers.

Following comic, let's talk about sense of humor. "Sense of humor" is heard very often. However not everyone can really understand its content and meaning. How to interpret "sense of humor"? First we should talk about its antonym "sense of dignity". Chinese people are often being said lack of sense of humor, which in other words means Chinese place a great emphasis on sense of dignity. Dignity is others respect to and viewpoint of you. But sense of dignity is the kind of sense extended from self-importance and egoism and being keep face-saving and pretended is the most concrete presentation of "sense of dignity". This kind of behavior can be very scaring and disgusting. We may say that "sense of dignity" is to balance a man's ignorance, emptiness and self-pity. It is a total reflection of a person's inferiority complex. Pretense and sense of dignity are comic's favorite attack target.

Wei-Li Liao's comic can be sorted into this category. His work makes readers feel preposterous at first sight. However if you adopt comic logic in reading his works, you will be able to read between the lines, and cannot help laughing from your heart and has a feeling of "Great minds think alike". Its irrationalism possesses positive value and persuasion. But based on the evaluation of the present market trends, comic doesn't have the selling points as strong as soap opera, mahjong and video games. I therefore conclude that Mr. Liao's comic has little chance to become best seller. Maybe this is a trial in the face of social reality. But if the result falls out of my expectation, it will in return become the first humorous news of the year in publishing industry. .

信筆揮灑的適情玩笑

偉立曾對我說他是隻台灣土狗，口氣很認真，也帶了些許驕傲。偉立當然不土，倒是「直」，而且「樸」。大概人只要又直又樸，「氣」就自然出來了，尤其看他頭戴藺草帽，穿條短褲，梭巡在工地間東指西點的時候，不僅眼神銳得發亮，平常話就不多，吐出的字句倒是都沉著、鏗鏘、有力。

我初識偉立是在十多年前當代藝術館由阮慶岳策劃的「城市謠言──華人建築展2004」展場上，妙的是當天只見其物未見其人。偉立擺了幾件得獎的建築模型，用硬紙板做的，有公廁有橋梁，皆輕巧有致（更妙的是，這幾件作品卻都因業主籌資無著而胎死腹中。）和別的參展者的作品大異其趣的，偉立也把「夢通霄」大刺刺的擺出來任觀者一窺其青春綺夢。簡單上了色的通霄老屋街景滿含懷舊情愫，而不失童稚的青澀文字，更讓我大開眼界。「竟有這樣的建築奇人！」但一直要到好幾年後，偉立的作品才得以面世，榮獲「美國國際宗教建築獎」殊榮的「礁溪長老教會」，則更是後話了。

這本漫畫集也是他伏蟄待孵時期的作品，詼諧、嘲諷卻不失於輕佻。認真的人開起玩笑來或率皆如此。值得注意的是他對數字、顏色（黑白對比）和均衡的偏執幾乎無可救藥，莫非是建築基因作祟？幾近誇大的女體令人不禁莞爾，似乎少年偉立在信筆揮灑之際，從中找到了更可恣意適情的空間？

讀書共和國社長　郭重興

MONOLOGUES

Wei Li once told me he is a Formosan dog. He sounded firm and serious, with a tinge of pride. Of course, his sense of belonging to his native land is not lame or crude. He is, instead, straightforward and sincere. A frank and austere person radiates that vibe naturally, especially when you see him passing through construction sites in short pants with a straw hat on. When he's supervising, not only his eyes are sharp, the words that don't easily come out of his mouth are composed, steady and powerful.

The first time I knew him was more than a decade ago, at Rumor of China Towns: Chinese Architecture Exhibition 2004, curated by Ruan Qing Yue. It was intriguing that I only saw his works, but not himself in person on that day. Wei Li displayed several awarded construction models made of cardboard, with public toilets and bridges within. They were all light and delicate, distinct from the ones presented by the other participants. What is more interesting is, none of these concepts was successfully realized ever after, due to failed fundraising of potential investors. Wei Li also enthusiastically exhibited Dream of Thong-Siau to let the visitors take a glimpse of his teenage dream. Colored simply, the image of the old street with chambers aligned was rich in nostalgic elements. And the immature text description really opened my eyes with its childlike innocence. "What an amazing architect!" But it was not until a few years later that his works were finally built, while IFRAA-winning Qiaoxi Taiwan Presbyterian Church was yet another story.

This comic collection presents his "incubation era" with humor and irony, but not frivolously at all. A serious man's way of joking must be like this. What is worth noticing here is his paranoia of numbers, black-and-white contrast, and balance. Maybe the gene of an architect is the reason behind it all. The exaggerated female bodies may make you smile awkwardly, and it seems like young Wei Li finds his space to exert his emotional power when he's drawing, right?

脳內補完

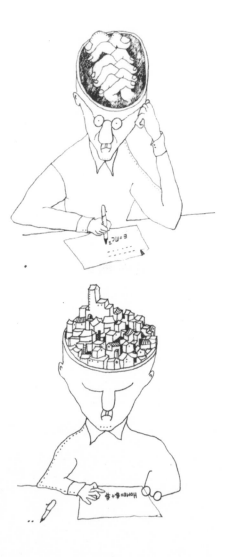

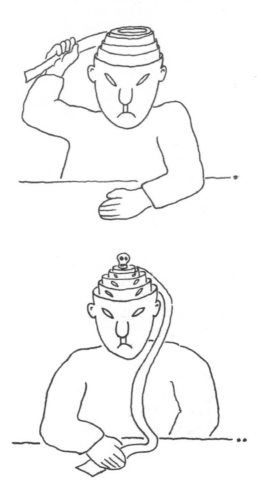

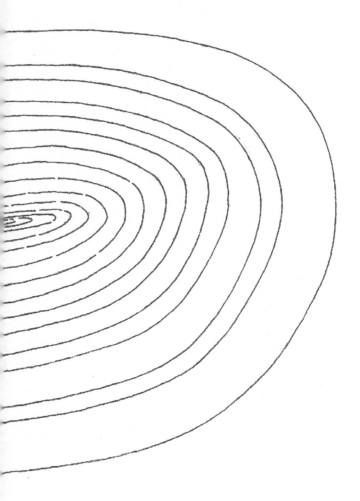

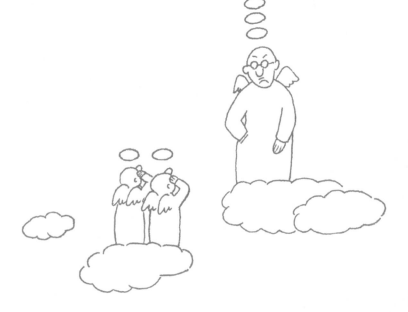

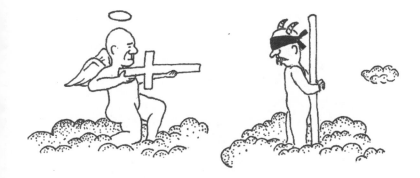

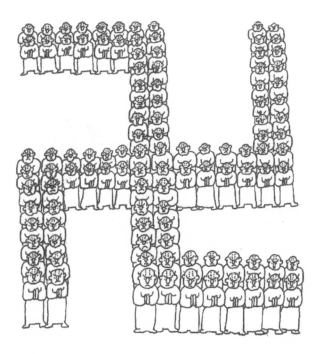

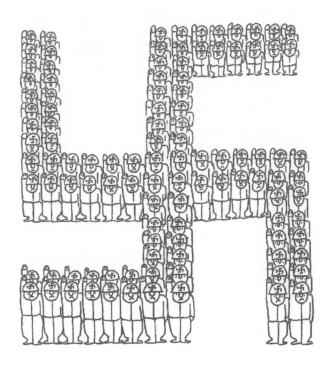

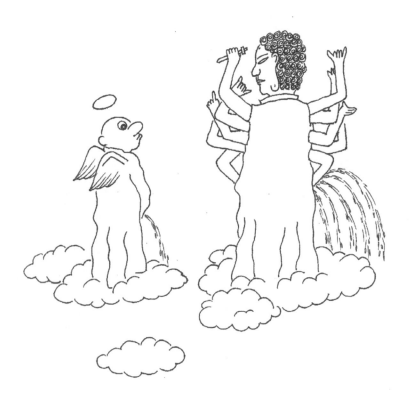

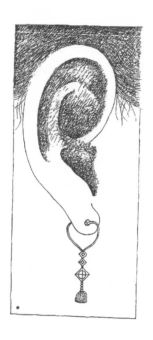

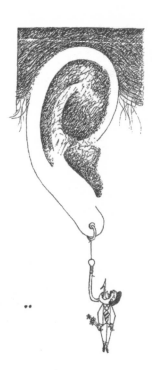

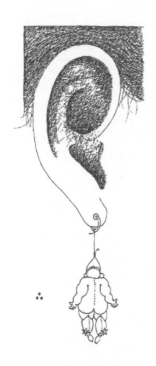

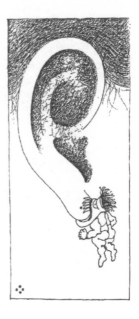

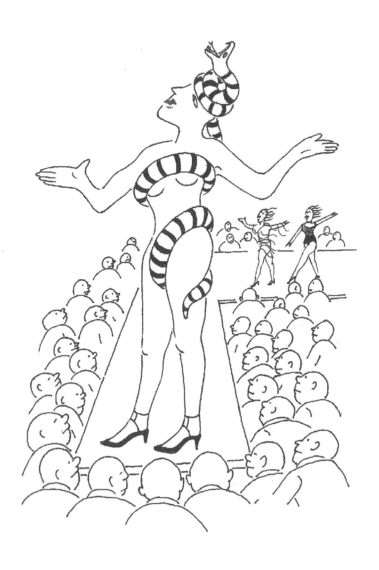

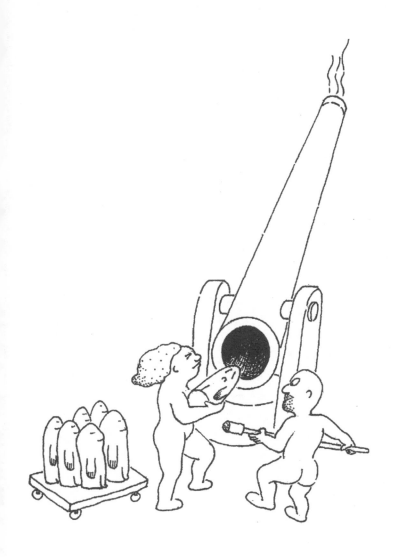

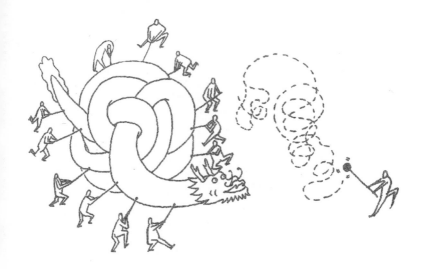

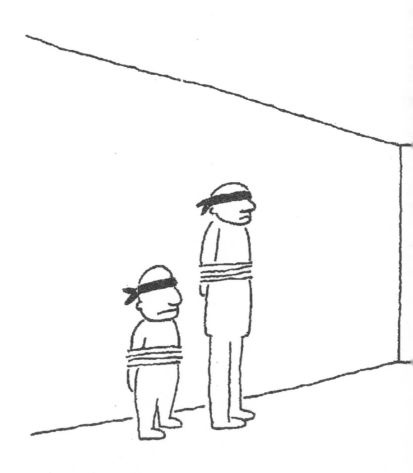

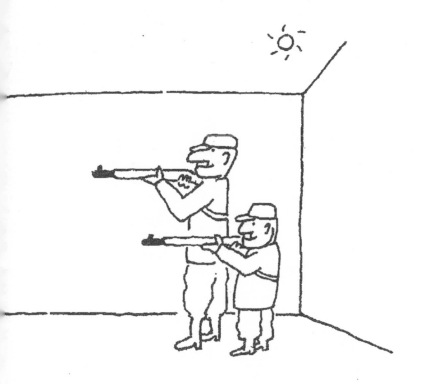

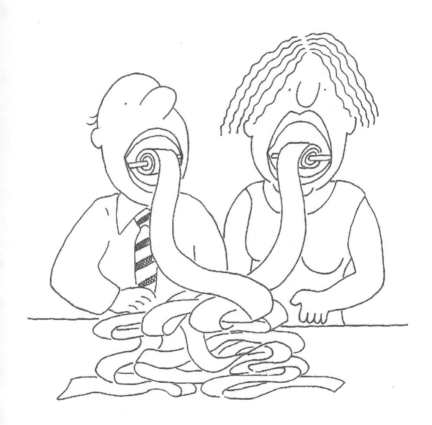

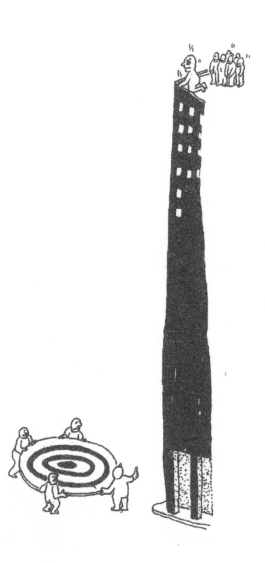

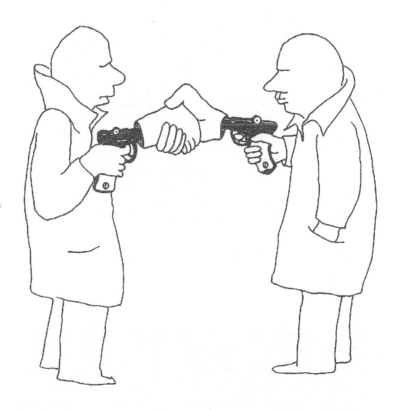

知也無涯

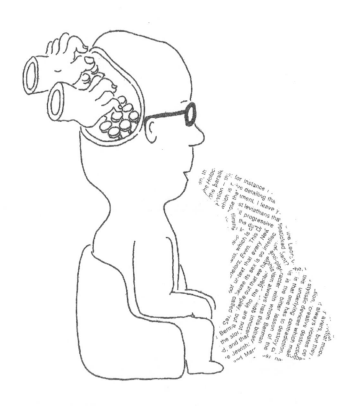

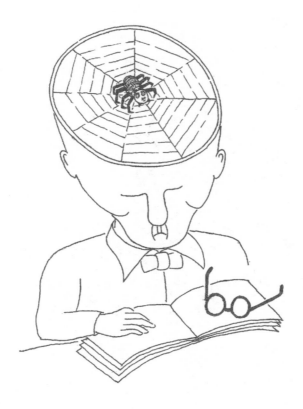

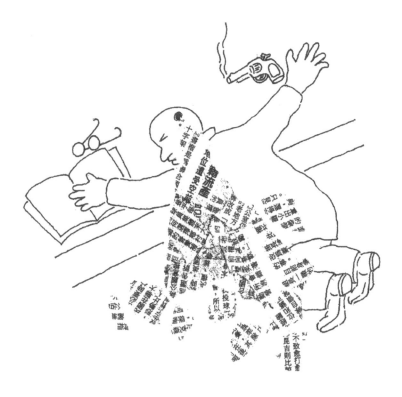

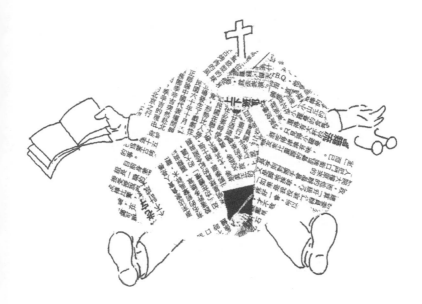

自作自受

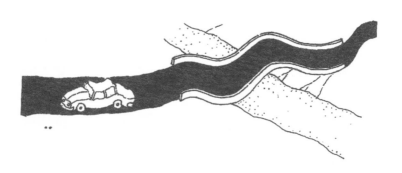

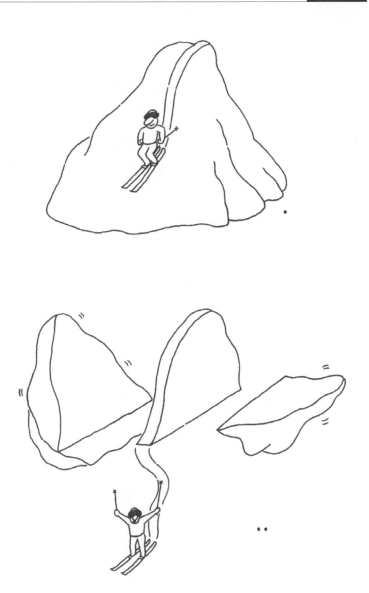

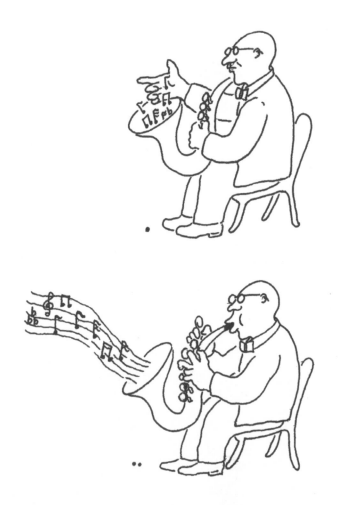

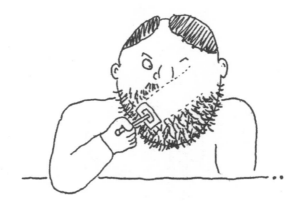

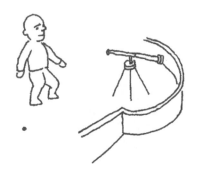

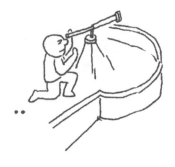

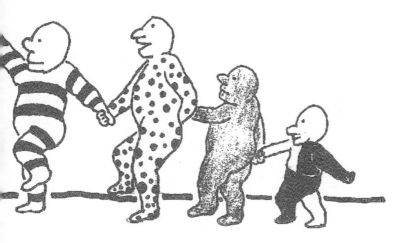

鑽石恆久遠

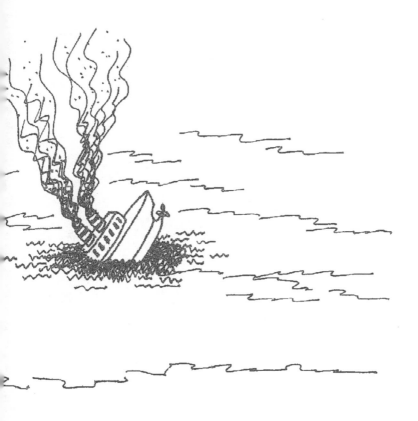

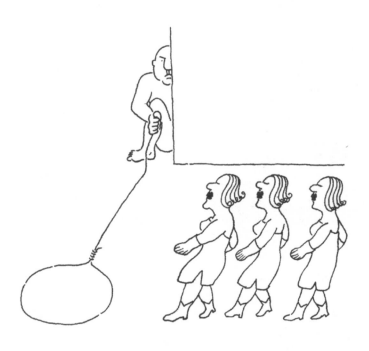

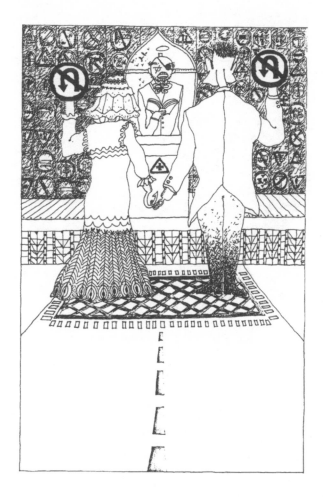

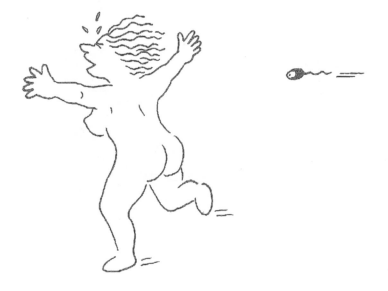

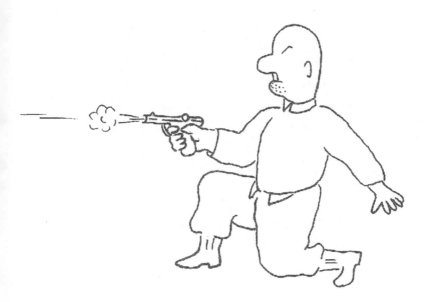

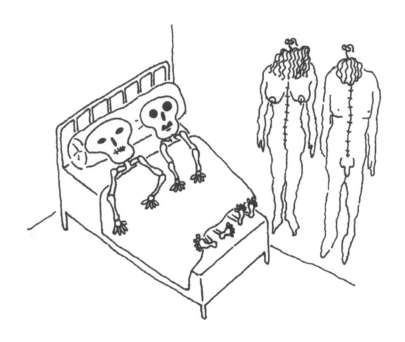

累積與宣洩

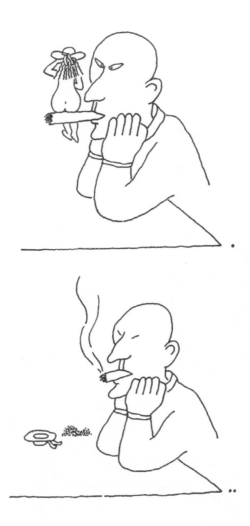

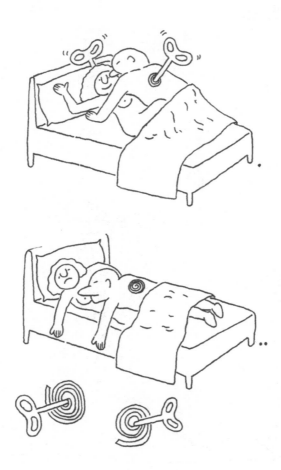

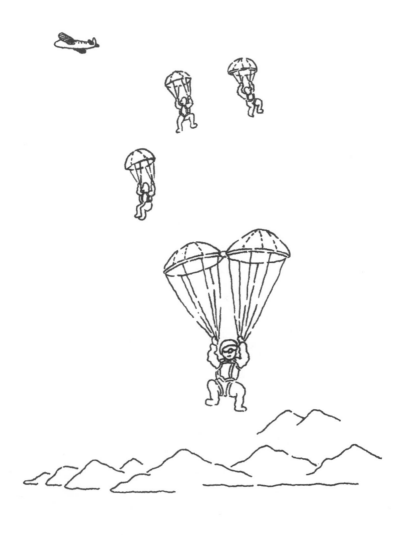

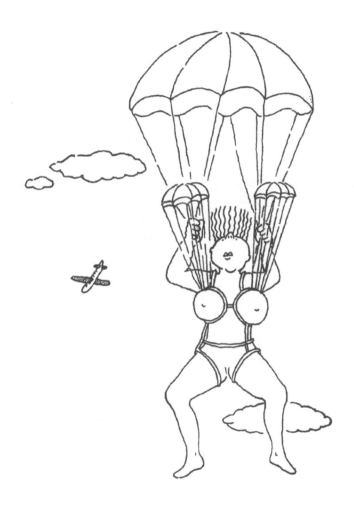

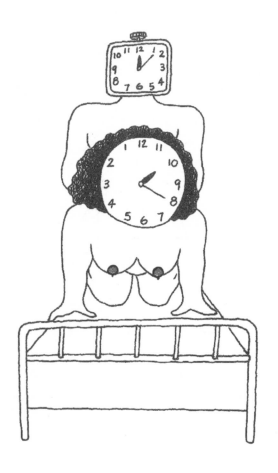

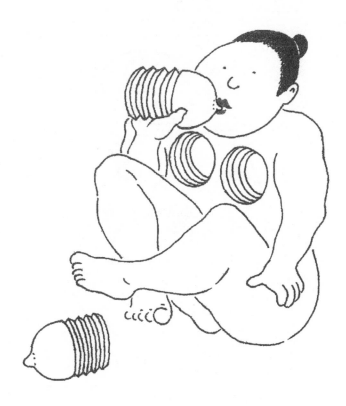

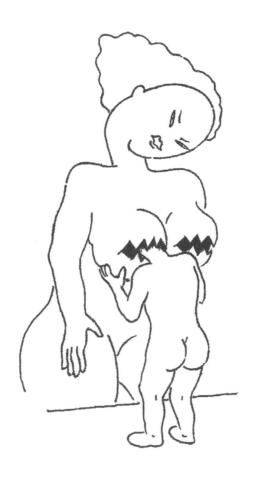

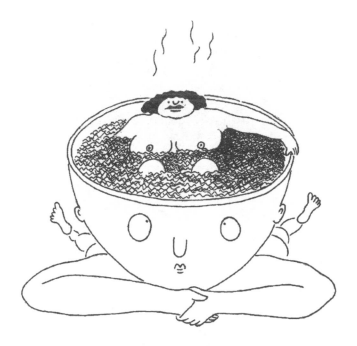

密件副本

密件副本

——

廖偉立漫畫集

腦內補完

知也無涯

自作自受

雙囍圖像 02
《密件副本：廖偉立漫畫集》

作者｜廖偉立
責編｜廖祿存
企畫｜許凱棣
封面設計｜羅俊驛
排版設計｜吳瑋翔

總編輯 ｜簡欣彥
社長｜郭重興
發行人兼出版總監｜曾大福
出版：遠足文化事業股份有限公司 雙囍出版
地址｜ 231 新北市新店區民權路 108-2 號 9 樓
電話 02-22181417
傳真｜ 02-22188057
Email ｜ service@bookrep.com.tw
郵撥帳號｜ 19504465
客服專線｜ 0800-221-029
網址｜ http://www.bookrep.com.tw
法律顧問｜華洋法律事務所　蘇文生律師
印製｜韋懋實業有限公司
初版 1 刷｜ 2021 年 12 月
定價｜新臺幣 360 元
ISBN ｜ 978-986-06355-7-7

國家圖書館出版品預行編目 (CIP) 資料
密件副本：廖偉立漫畫集 / 廖偉立繪 . 著 .
-- 初版 . -- 新北市：遠足文化事業股份
有限公司　雙囍出版 , 2021.12
104 面；12.8x19 公分 . -- (雙囍圖像；2)
ISBN 978-986-06355-7-7(平裝)
947.45　　　　　　　　　110019784